The Farmyard Set

The Farmyard Set

Hannah Dale

BATSFORD

For my Wrendale family – thank you for all of your hard work,
dedication and for making every day a lot of fun!

First published in the United Kingdom in 2018 by Batsford
43 Great Ormond Street, London WC1N 3HZ
An imprint of B. T. Batsford Holdings Limited

This edition first published in 2024 by B. T. Batsford

ISBN: 9781849949248

A CIP catalogue record for this book is available
from the British Library.

10 9 8 7 6 5 4 3 2 1

Reproduction by Mission, Hong Kong
Printed and bound by Toppan Leefung Printing Ltd, China

This book can be ordered direct from the publisher at the
website www.batsfordbooks.com, or try your local bookshop.

MIX
Paper | Supporting
responsible forestry
FSC
www.fsc.org
FSC® C104723

Contents

Introduction

To say that the animals featured here have shaped our very
existence is no exaggeration, and this book is intended as a
celebration of, and tribute to, the amazing variety of breeds
that have played such an important role in our history.

My love for farm animals began as a small child – living in
the Lincolnshire countryside, we were surrounded by sheep,
cows and pigs of all descriptions. Our garden backed onto a
field that was home to a herd of beautiful Lincoln Reds, and
some of my fondest childhood memories are of bottle-feeding
orphan lambs or chasing playful piglets around a barn at a local
farm. An early ambition to be a farm vet (largely motivated by
obsessive consumption of *All Creatures Great and Small*, the
1980s television adaptation of the diaries of Yorkshire vet, James
Herriot) shifted as I grew older and instead I studied Zoology,
which encompassed a broader spectrum of life on Earth, but
my respect and love for farm animals has not diminished.

Our relationship with domesticated animals goes back a long
way – over 10,000 years to be precise – and we owe them a huge
debt of gratitude. It is thought that sheep were among the first
animals to be domesticated somewhere in the Middle East, and
this transformed the human species from hunters into nomadic
farmers who moved around with their flocks, following them

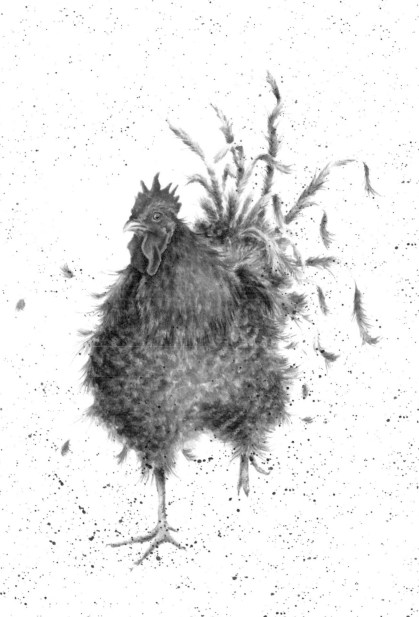

to fresh pastures. As well as providing meat, these animals also gave our ancestors milk products, manure to fertilise crops, wool and skins for clothing, and horn and bone for tools. Without this close association with their animals, humans would never have achieved what they have today.

As well as shaping our own evolution, farm animals have also moulded some of our most iconic landscapes. The most striking examples are the hills and uplands, where grazing livestock not only form the backbone of rural economies, but by happily munching away they reduce the dominance of invasive species, which allows native plants and trees to flourish and in turn provides habitats for an abundance of life. The dry-stone walls that criss-cross the countryside were originally built to protect and contain flocks and herds of livestock and are now an important and valuable feature of the landscape.

This book includes a number of breeds now considered to be endangered – between 1900 and 1973 when the Rare Breeds Survival Trust was established, many native breeds, including the fabulous curly coated Lincolnshire pig, have become extinct and many more have been rescued from the brink by a handful of dedicated and devoted pioneers. As important as any historical building or landscape, the wonderful variety of domestic breeds offers an insight into our cultural and historical heritage. In addition, as more breeds die out the

gene pool is becoming increasingly narrow, meaning that surviving animals will be more vulnerable to devastation by illness and disease.

Much has been said about the treatment of some commercially farmed animals around the world, and thanks to the dedicated work of campaigners, there have been vast improvements, but sadly the lives of many beautiful, intelligent and innocent animals are not happy ones. Consequently, many people choose not to eat meat or indeed rely on any animal-derived products. I do not intend this book to be an endorsement of any particular lifestyle choice, but a rather a means to increase awareness of the animals to which we owe so much. However, I do believe that, at the very least, we have a responsibility to these wonderful creatures to ensure that their lives are as rich and comfortable as possible, and to support the farmers whose values are aligned to the highest standards of welfare.

Our countryside is inexorably linked to the livestock that fill the fields, pastures and hillsides. These populate the books we read to our children and, for me, early relationships with these animals helped to form a deep respect and love for wildlife in all its forms. I have loved working on the illustrations in this book; I have tried to capture some of the spirit and personality of the breeds and it has been a joy to learn more about many of their histories. I hope that you enjoy it!

1
Brood
(Hens)

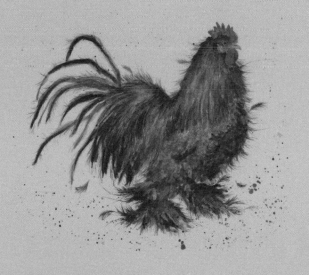

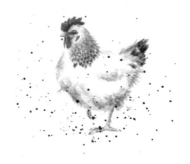

Sussex

The Sussex is the most distinguished of fowl with a long history.
It is thought to have first been bred in England during Roman times,
making it one of the oldest breeds. Calm and friendly, the hen is
an excellent mother and a prolific egg-layer. Adaptable to most
conditions, she is a vocal bird, and you will never be short of
company with Sussex hens and their gentle chatter.

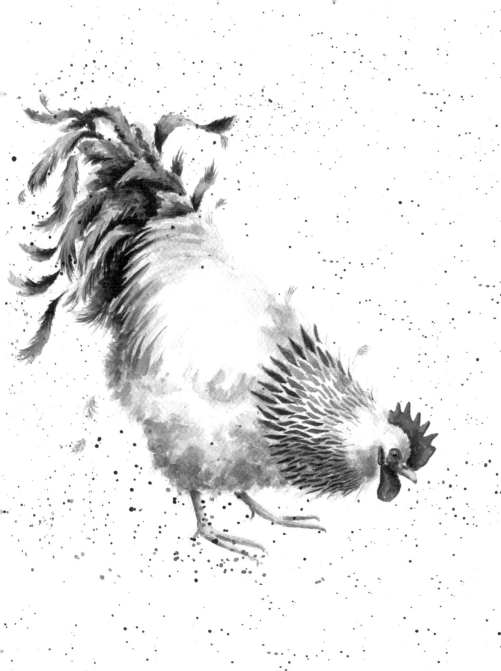

Cochin

The Cochin is best known for its abundance of fabulous, fluffy feathers, adorning not just its body but its feet as well. The hen isn't a prolific egg producer, but more than makes up for this with her gentle and sweet personality and she makes a wonderful pet. Given the chance, a Cochin will swiftly become part of the family, often padding into the kitchen on her feathery feet in search of a treat. The Cochin originated in China but made its way to Europe and the UK in the 1840s. Queen Victoria is said to have been a fan of this beautiful breed, which led to a surge in the popularity of keeping poultry.

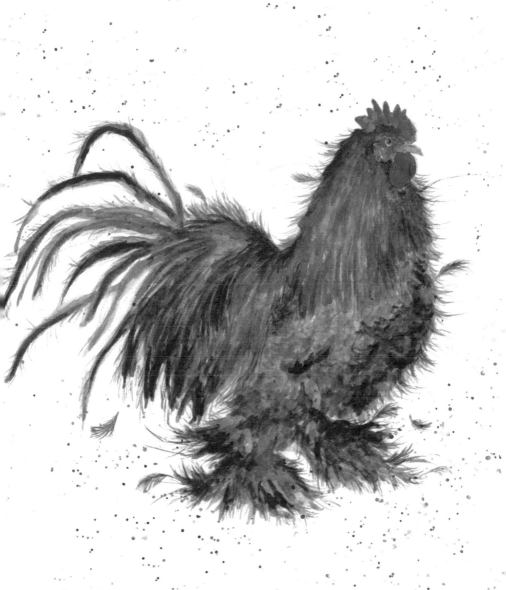

Orpington

The wonderful Orpington chicken is named after the Kent town
where the breed originated in the late 1800s. The hen is a good layer
but is most valued for her large size and entertaining personality. The
Orpington comes in four colours – black, white, blue and buff, with
buff being by far the most popular. The hen is also extremely docile
and friendly and makes a wonderful pet. This is another breed with
a royal connection – the late Queen Elizabeth, the Queen Mother
was a huge fan and owned an award-winning flock.

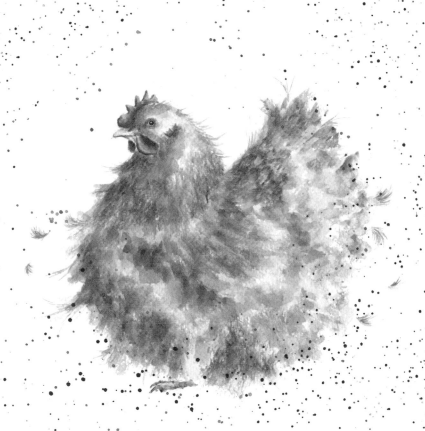

Rhode Island Red

With its deep russet plumage and ruby-red comb, the Rhode Island Red is one of the most attractive chicken breeds. It was first bred in America in the 1800s and is so loved that it has become the state bird of Rhode Island – one of only three state birds to be assigned that are not a native species. The hens are prolific layers and are very hardy birds, making them suitable for most gardens.

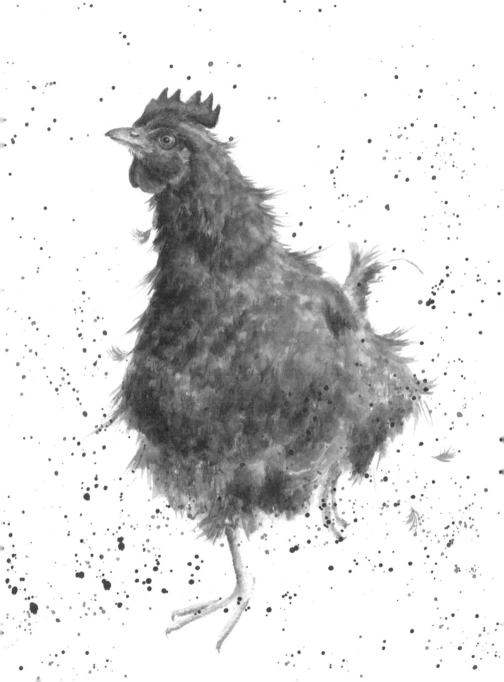

Wyandotte

The Wyandotte is the glamour girl of the henhouse, strutting
her stuff in a showy yet elegant manner. The breed comes in a wide
variety of colours but is often adorned in the beautiful lace pattern
for which the breed is renowned. As befitting any self-respecting diva,
the Wyandotte has a strong personality but is generally easy-going
and is a good breed for new hen owners. Originating in America, the
Wyandotte is a good layer, producing up to 200 brown eggs a year.

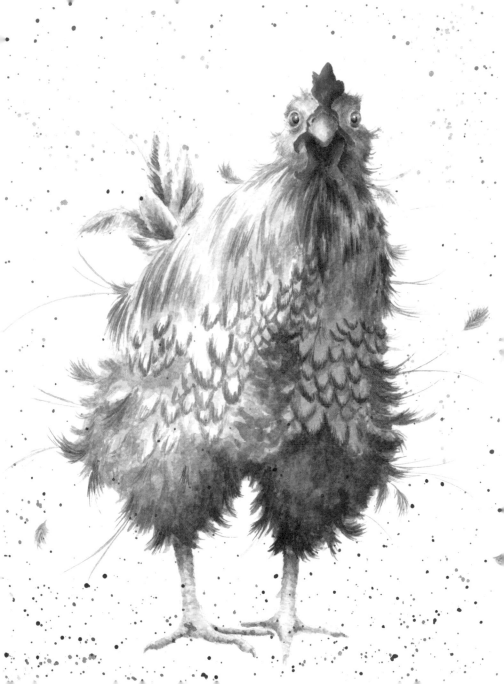

2
Drove
(Pigs and Donkeys)

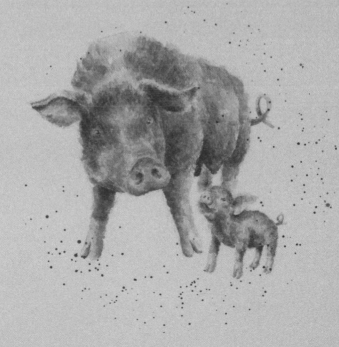

Gloucestershire Old Spot

Intelligent, gentle and hardy, the Old Spot originated in the orchards
of Gloucestershire. Although it was officially recognised as a breed in
1913, spotted pigs, thought to be the ancestors of the Old Spot, have
been around for centuries. Sometimes known as the Orchard Pig,
it was once thought that the Gloucestershire's signature spots were
bruises caused by falling apples.

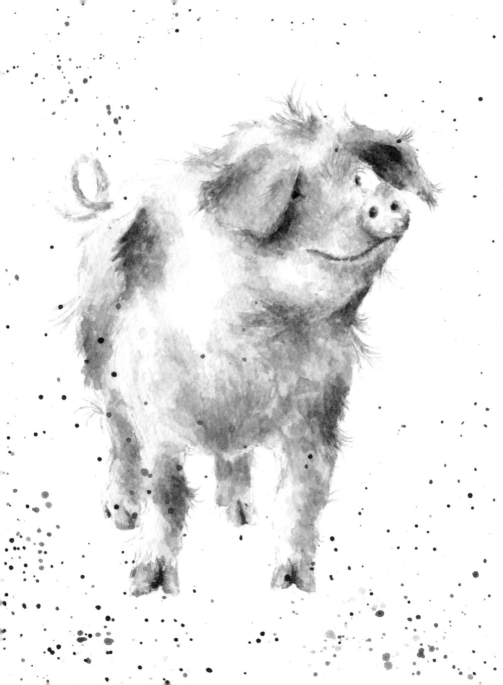

Saddleback

The modern British Saddleback is descended from two similar
breeds, the Wessex and Essex Saddlebacks, both now extinct in
Britain. Unmistakable with its lop ears and pink belt around its
middle, the Saddleback is an avid forager and is very hardy.
The sows are excellent mothers and their gentle nature makes
it a popular breed for smallholders.

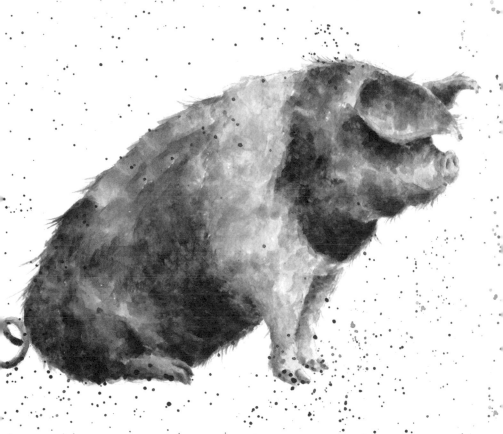

Tamworth

The redhead of the pig world hails from Staffordshire, and is one of our oldest breeds, most closely related to the wild pigs that roamed the forests of Britain centuries ago. Wiry ginger hair protects the Tamworth from the sun but, during the hottest months, it still relies on a good old-fashioned mud bath to protect its skin from the harmful rays. Hardy and resilient, the Tamworth does well in harsh weather conditions and thrives in Scotland and Canada.

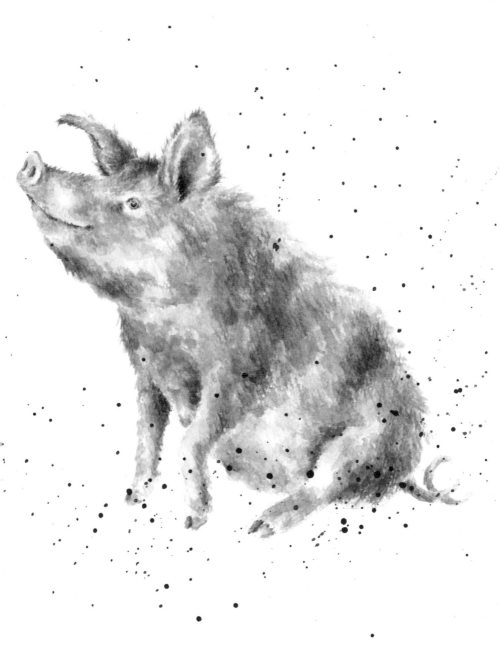

British Lop

The British Lop originally comes from the West Country where it
descended from the white lop-eared pigs that graced farmyards in
that part of the country for centuries. It is so much identified with the
West Country that some breeders call it the Cornish Lop. The British
Lop became very rare in the 1940s when the war effort demanded
that breeders focused on more productive commercial breeds. While
its numbers are still low, and it remains one of the rarest of the rare
breeds, its future is looking brighter and its numbers have picked up.

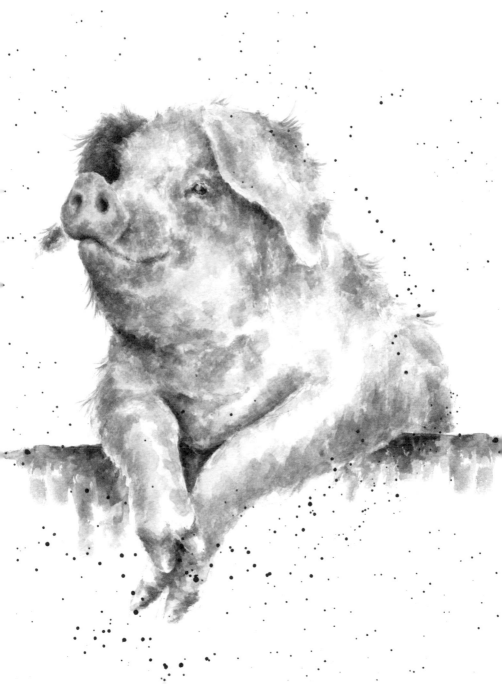

Oxford Sandy and Black

The Oxford Sandy and Black is an old breed, with its origins in Oxford (as the name would suggest) over two centuries ago. The distinctive markings have earned it the name the Plum Pudding Pig and the colouring protects it from sunburn. The breed has had a few close shaves and was brought back from the brink of extinction 20 years ago thanks to dedicated breeders who believed that the breed was worth saving. It is no wonder that it attracts such devotion with its good looks, gentle nature and easy-to-care-for reputation.

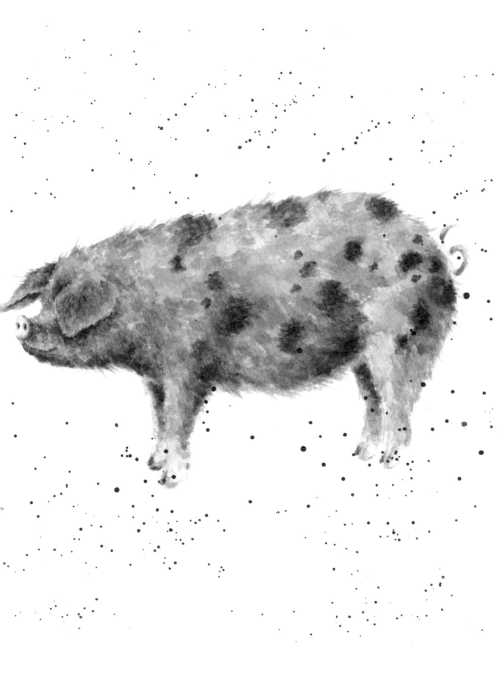

Berkshire

The Berkshire has enjoyed some fame over the years, starring in George Orwell's *Animal Farm* as the notorious Napoleon and, rather more flatteringly, as Pig Wig in Beatrix Potter's *The Tale of Pigling Bland*. It was oddly known as the Lady's Pig, perhaps due to its friendly and curious nature and good looks; Queen Victoria is said to have been a fan of the breed.

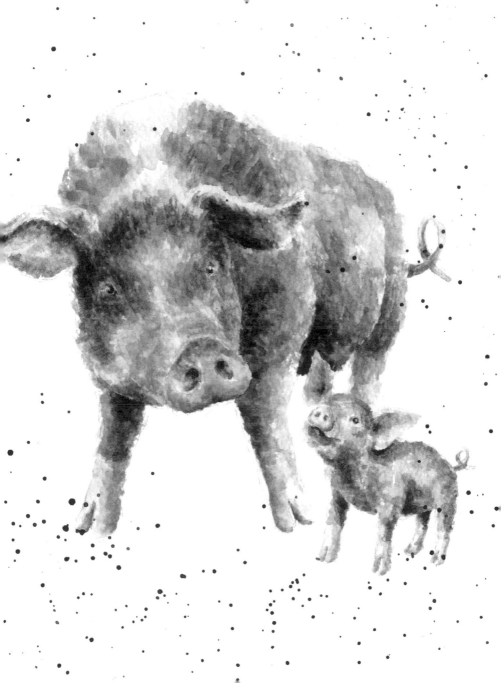

Large White

If you come across a pig, it's very likely to be a Large White. This is because this is one of the most populous of all pig breeds. It originated in Yorkshire and is often called the Yorkshire Pig. The Large White is very intelligent (as are all pigs) and is most content when coated in a generous layer of mud. This not only protects it from sunburn but also helps to keep it cool in hot weather – pigs can't cool down by sweating. Rather confusingly, the phrase 'sweating like a pig' actually refers to pig iron which appears to sweat as it cools after the smelting process.

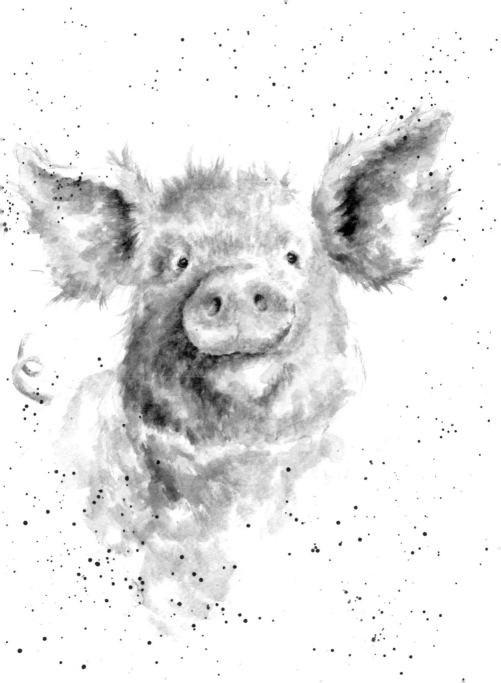

Mangalitsa

The original 'sheep-pig', you'd be forgiven for doing a double take when setting eyes on a Mangalitsa. With its curly locks, it looks as though it would be more at home in a flock of sheep than in a pigsty. It comes from Hungary, where it was the result of breeding Hungarian breeds with a European wild boar. The only other curly coated pig is the Lincolnshire Curly Coat, which sadly became extinct in the 1970s.

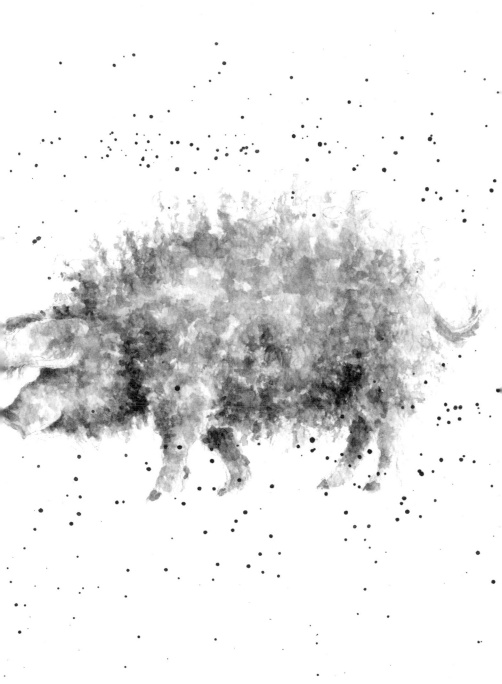

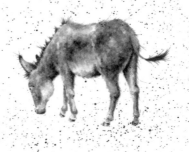

Donkey

The donkey is one of the hardest working of all domesticated animals – there are over 40 million donkeys worldwide, many of them used as working animals. First domesticated around 3000BC, the donkey has played a huge role in civilisation, which is evidenced by the numerous times donkeys are mentioned in literature and popular culture – from the Bible through to Shakespeare and *Shrek!* Known as a stubborn animal, this does the humble donkey a disservice as they are gentle, intelligent, curious and resilient.

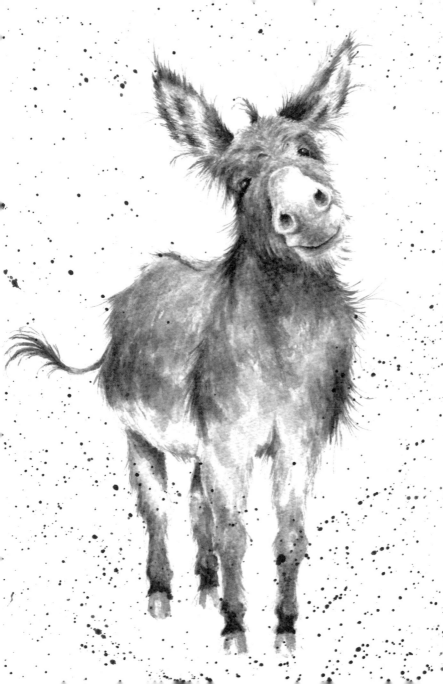

3
Team
(Horses and Ponies)

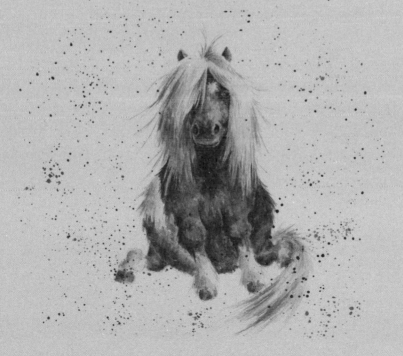

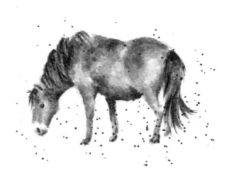

Exmoor Pony

The windswept moors of Exmoor in Devon and Somerset have been
home to ponies since 50,000BC, and the hardy little Exmoor can still
be found roaming semi-wild. The much-loved Exmoor also has a
close association with humans and is considered an excellent pony
for children. Sadly, the breed almost became extinct after the Second
World War, when Exmoor was used as a training ground by soldiers;
many of these beautiful animals were killed or stolen and only
50 ponies survived. The breed has continued thanks to the efforts
of some dedicated breeders, but it is still considered endangered.

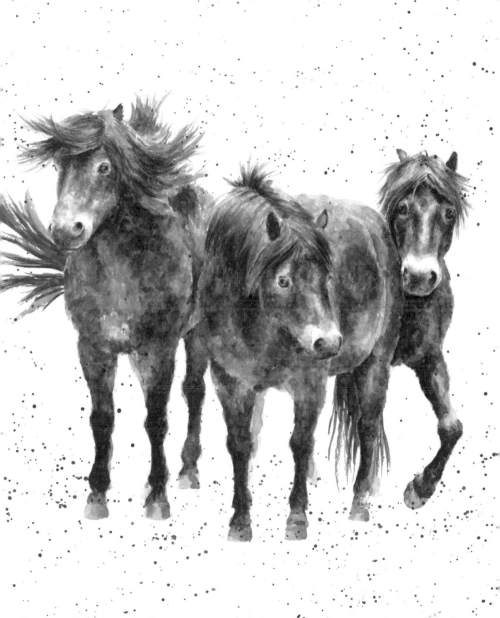

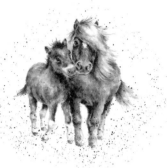

Shetland Pony

The diminutive Shetland Pony is instantly recognisable and much loved. The sturdy little pony has a thick coat and is well equipped to thrive in the tempestuous weather conditions of its original home on the Shetland Islands. Able to pull twice its own body weight, the Shetland is the strongest of all horse and pony breeds weight for weight, and their pony power has been exploited extensively in the past when they were used to pull carts carrying peat and coal. This intelligent little horse can also be used as a 'guide pony', fulfilling the same role as a guide dog.

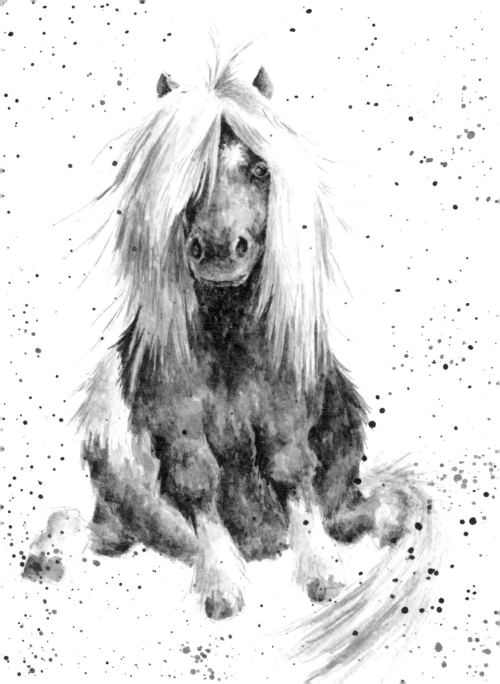

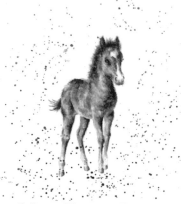

New Forest Pony

The iconic New Forest Pony is thought to have existed in Hampshire for many thousands of years. Although it is well loved as a riding and working pony thanks to its intelligence, gentle nature, strength and versatility, some also roam semi-wild throughout the area that was designated a National Park in 2005. All of the ponies grazing in the New Forest are traditionally 'owned' by the New Forest 'commoners' and they are taken care of by people known as Agisters who ensure their welfare and good health.

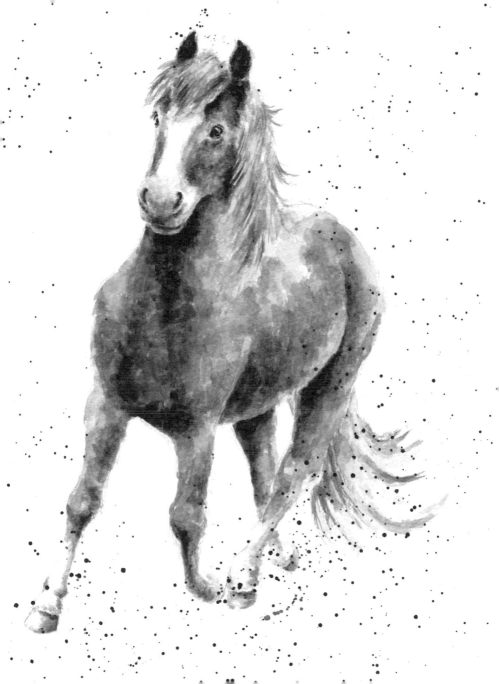

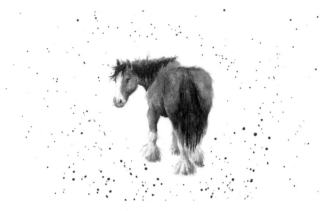

Shire Horse

Truly the gentle giant of the equine world, the Shire Horse has a long association with humans, and has been by our side on the battlefield and on farmland, always a faithful companion. Although its exact origins are unknown, it is originally thought to have come from the counties of Lincolnshire or Cambridgeshire. Strong and gentle, Shires are classed as 'cool bloods' due to their quiet and calm temperament. They are known as draught horses, a term derived from the Anglo-Saxon word meaning 'pull' or 'haul', and the Shire horse is still used in forestry today.

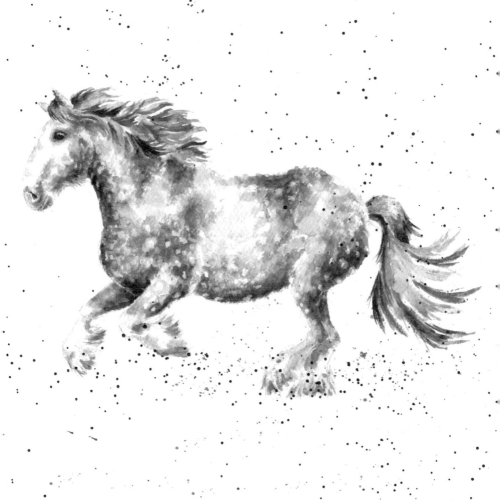

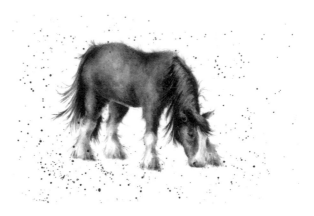

Clydesdale Horse

The Clydesdale is the Scottish draught horse, originally used for agriculture and hauling coal. During the 1920s it was a more compact horse but has since been bred for size and now stands as one of the largest horses in the world – its feet are famously the size of dinner plates! Well-known for its gentle nature and feathery feet, Clydesdales are usually bay coloured.

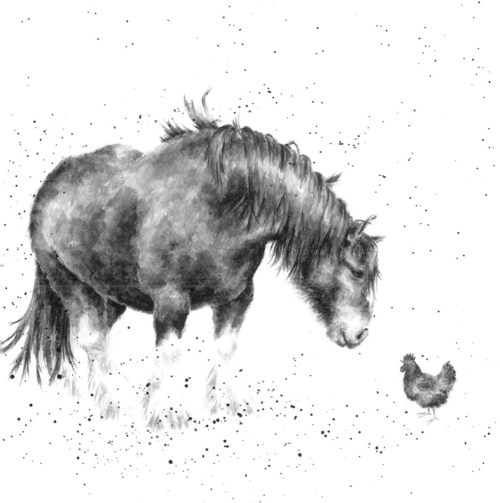

Welsh Pony or Cob

A Welsh Pony or Cob is one of the most popular riding ponies in the world – it is beautiful, versatile and gentle, making it particularly suitable for children. Herds of wild ponies have roamed free on the mountains of Wales since before Roman times and were often tamed and used by hill farmers. The Welsh Ponies we are familiar with today are ancestors of these wild ponies, which were then bred with Arabian horses and Thoroughbreds. They are still hardy little animals, can withstand harsh climates and are strong for their size.

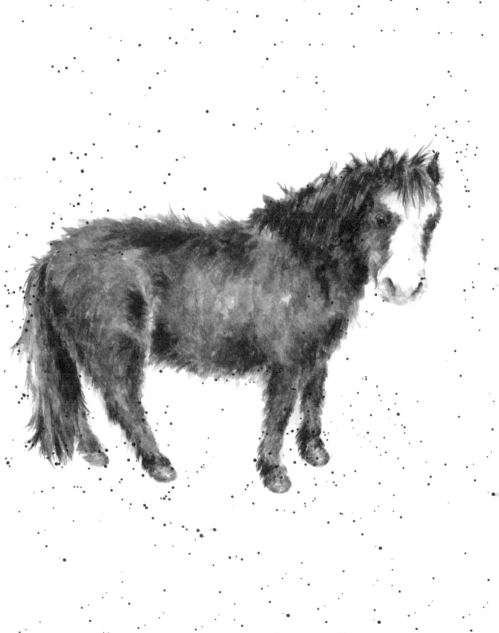

Suffolk Punch

The Suffolk Punch was originally known as the Suffolk Sorrel and dates back to the 16th century. It earned the name 'Punch' due to its solid appearance and strength. The Suffolk Punch is always chestnut in colour and does not have the feathery feet characteristic of other draught horses. Shorter but more solidly built than a Shire or Clydesdale, it was developed for agricultural work, with a powerful, arching neck and short, muscular back.

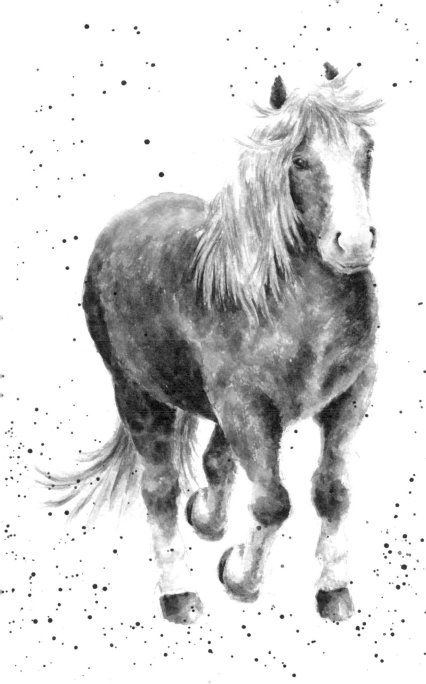

Connemara

The Connemara is native to the west of Ireland, an area defined by its rugged but beautiful landscape. Here, the Connemara has adapted to live among the moors and marshes that can often be desolate and battered by the weather. Well-known for bonding strongly with its owners, the Connemara is a popular riding pony and is competitive in show jumping, dressage and eventing, while also having the stamina for endurance riding.

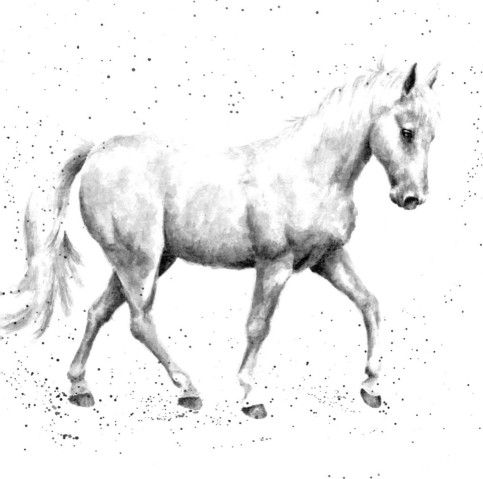

4
Raft(er) and Gaggle
(Ducks, Turkey and Geese)

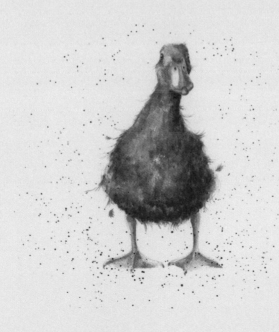

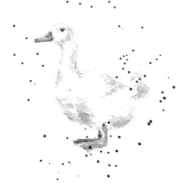

Aylesbury Duck

The Aylesbury Duck was originally known as the White English Duck until 1815 when it was renamed after its place of origin – the town of Aylesbury in Buckinghamshire. Immortalised by Beatrix Potter as Jemima Puddle Duck, Aylesbury ducks were bred for their meat and feathers. The part of the town in Aylesbury where the ducks were reared, often in people's homes, was known as Duck End. In recent years, the popularity of the Aylesbury Duck has declined, and the breed is now critically endangered.

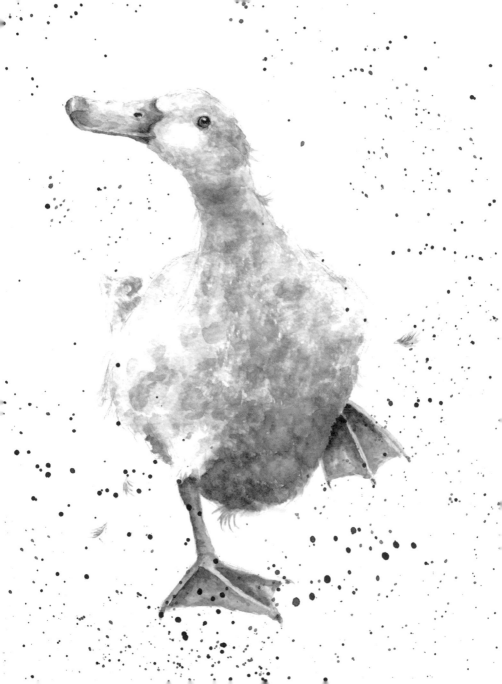

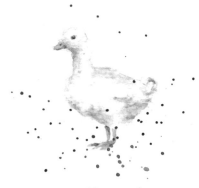

Call Duck

As the name would suggest, Call Ducks are famous for their vocal ability, with a high-pitched call that carries over long distances, which means that keeping Call Ducks may not make you too popular with the neighbours ... They are related to mallards, but are smaller with a short beak, which makes them look as if they have just stepped out of a story book. They were introduced in the 1800s as a decoy duck to attract wild birds during hunts. A charming and fun breed, it is now kept mostly as a pet.

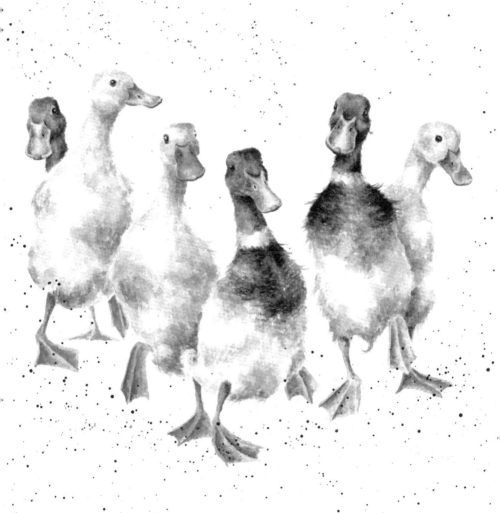

Campbell Duck

The Campbell Duck gets top marks when it comes to laying eggs –
it is prolific, laying up to 300 per year. It is an avid forager, and makes
short work of slugs and snails in the garden, and is a gentle and
friendly soul. The Campbell was originally bred in Gloucestershire, by
a Mrs Campbell, and comes in three colours, khaki, white and dark,
with khaki being the most famous. Mrs Campbell was actually trying
to breed a buff-coloured duck, but a muddy brown khaki colour was
the closest she ever got.

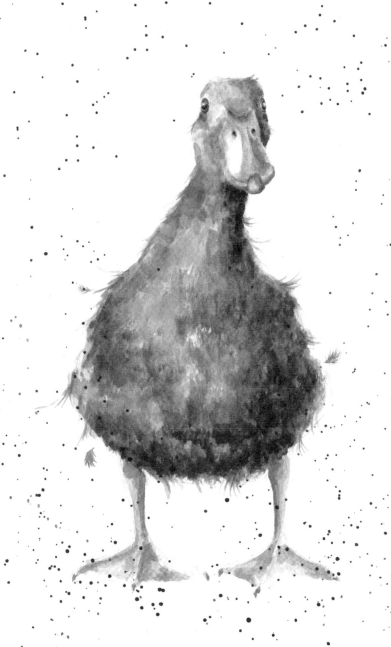

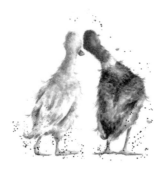

Indian Runner Duck

Standing tall like a penguin, the Indian Runner Duck is very distinctive, and its quirky appearance has led to it developing a cult following in recent years. Despite the name, the breed originates in South-east Asia, and it is a prolific egg layer. It doesn't fly and rarely builds a nest to incubate its eggs. Instead, it walks or runs, dropping its eggs wherever it happens to be at the time.

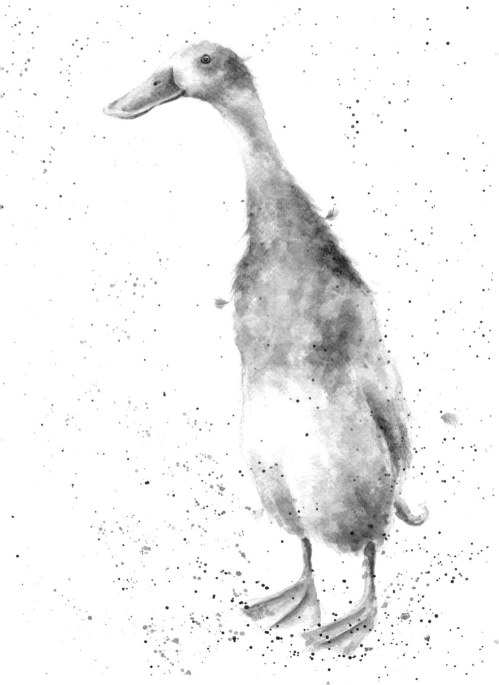

Bronze Turkey

Turkeys were first brought to England in 1526, but it wasn't until Edward VII enjoyed a turkey for his Christmas dinner that they really began to grow in popularity. Until the 1950s they were a real luxury – in 1930 a turkey cost a week's wages. The famous gobbling sound is only made by the male; the female makes more of a clicking noise. The Bronze Turkey is the commercial breed most similar to the wild turkey and is named after its plumage that has a lustrous sheen.

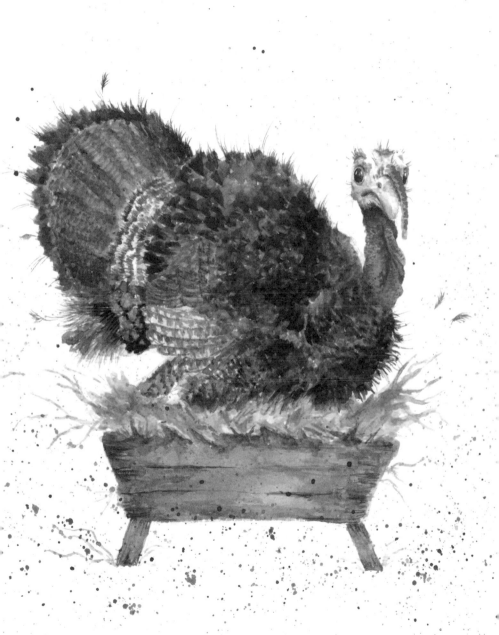

Embden Goose

The Embden Goose is one of the oldest domestic goose breeds –
its exact origins are uncertain, but it is thought that it originally came
from northern Germany. With its white plumage, orange feet and
beak and striking blue eyes, it is a beautiful bird and epitomises most
people's idea of a farmyard goose. The honking ganders are more vocal
than the females who chatter quietly most of the day, and the ganders
are extremely protective, which has earned them a reputation for
being aggressive.

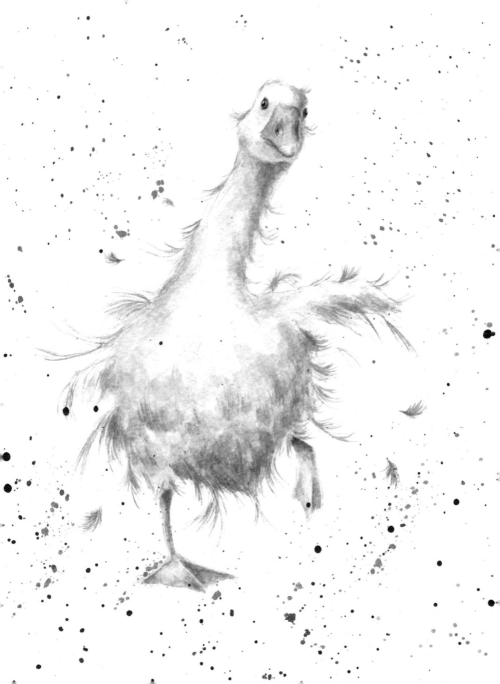

5
Herd
(Cows and Alpacas)

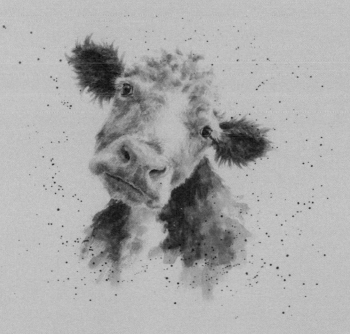

Belted Galloway

Belties, or Oreo Cows, thanks to their distinctive markings, originated in Scotland where their hardy nature makes them well-suited to harsh weather conditions. Their long curly coat, as well as making them look like teddy bears, protects them from the rain, while a soft undercoat keeps them toasty warm in the coldest of conditions. With a gentle and placid personality, the Belted Galloway is a popular cow and is no longer considered a rare breed.

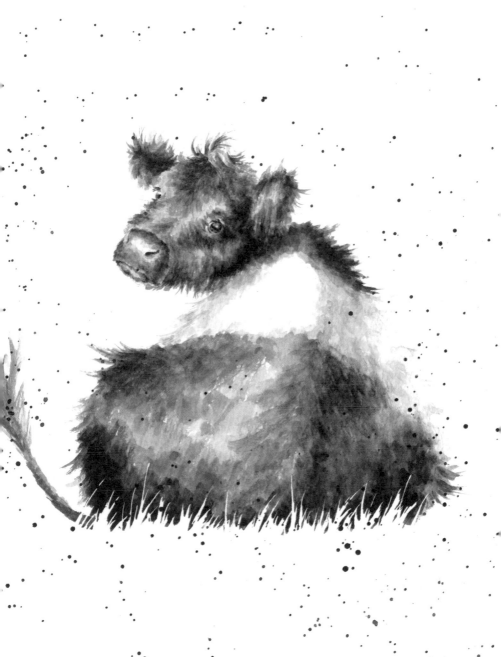

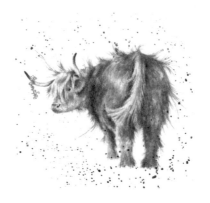

Highland Cow

One of the most beloved and iconic of all cattle breeds, it's not hard to see why so many people love the 'Heelan Coo' as it is known in its native Scotland. With its irresistible bed-head hair, teddy-bear face and beguiling eyes, this beautiful animal is also known for its gentle nature. Although most people associate the russet colour with the Highland Cow, its coat can vary greatly, anywhere from white right through to black. A group of Highland cattle is known as a fold rather than a herd.

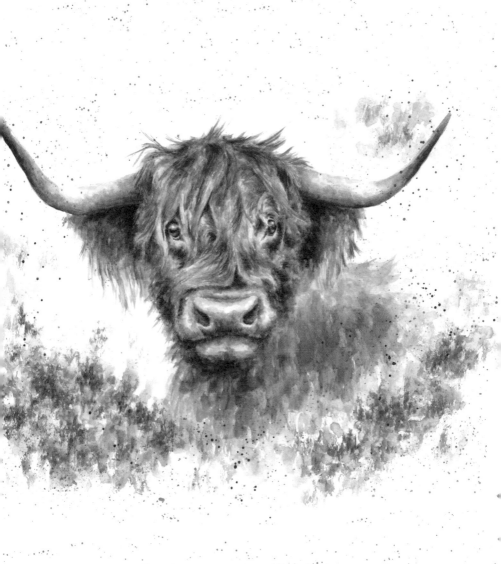

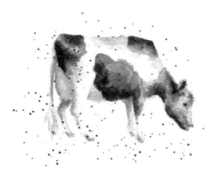

Friesian

The beautiful black and white Friesian has become synonymous with the countryside pastures it makes its home. It originated in an area called Frisia in the north of Holland, where the rich land produced some of the best grass in the world. Famous as the most prolific dairy cow in the world, the handsome Friesian arrived in Britain in the 18th century. The Friesian is often crossed with the Holstein to create the similar but larger Holstein-Friesian.

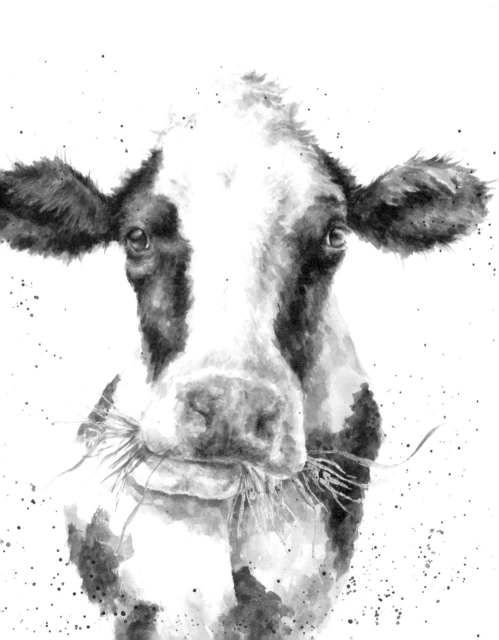

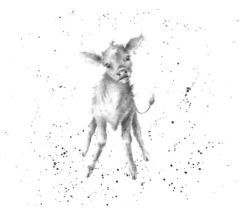

Jersey

The Jersey Cow is the belle of the ball with her large brown eyes and beautiful long lashes. Not just a pretty face, the milk of the Jersey Cow is rich and delicious, with more fat than your average milk. The Jersey is also a docile and friendly breed, its pleasant and gentle nature adding to its appeal. As you would expect, the breed originated on Jersey in the Channel Islands and was first recognised as a separate breed in 1700.

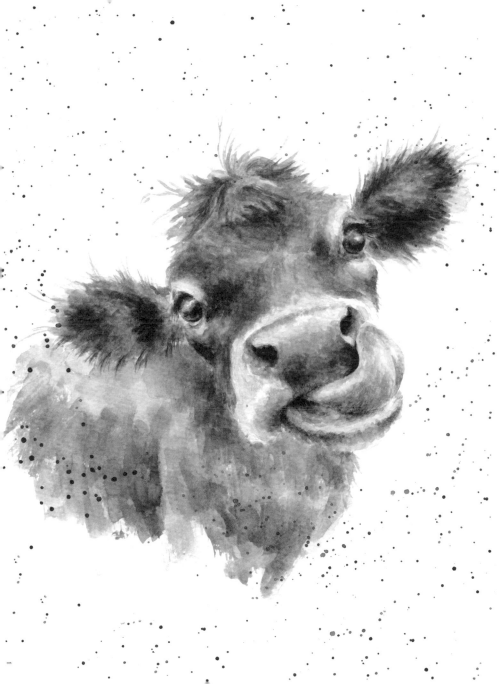

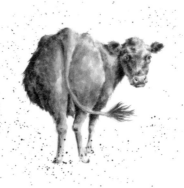

Aberdeen Angus

The Aberdeen Angus is one of the most famous breeds of cattle,
hailing from Scotland where it is known as the Angus Doddy
(this sounds best when spoken by a true Scot). It is bred for its beef,
which is considered by many to be the finest in the world. Amazingly,
the breed can be traced directly back to two original ancestors
from the 1800s.

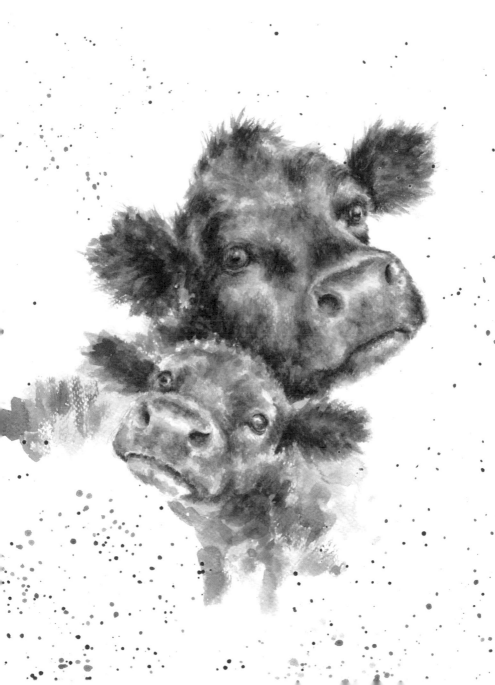

Hereford

The Hereford is instantly recognisable with its russet coat and white face. It is an old breed and is thought to descend from the ancient cattle of Roman Britain. There are now over five million Hereford cattle worldwide. The Hereford is a gentle animal, and is very adaptable, thriving anywhere from Scotland to Australia.

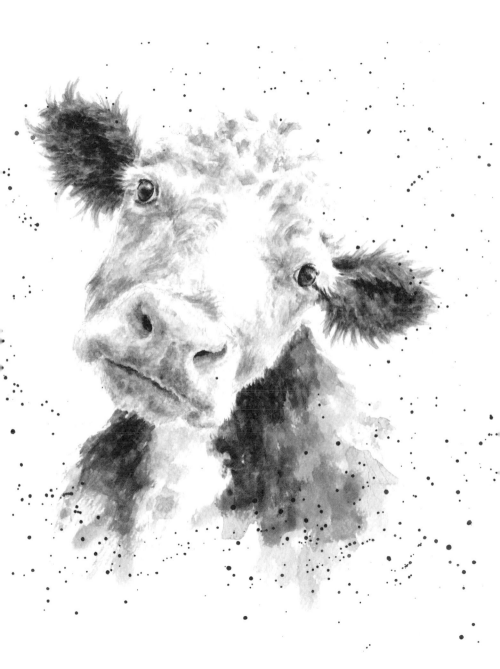

British Blue

The British Blue is an impressive beast by anyone's standards –
with rippling muscles and an imposing stance, you'd be forgiven for
thinking that the British Blue is an animal to be feared, but despite
appearances, it is a gentle giant. It owes its imposing physique to a
genetic mutation that results in a condition called double muscling.
The roan coloration has a bluish appearance, hence the name,
but in fact the British Blue can vary in colour from white
through to black.

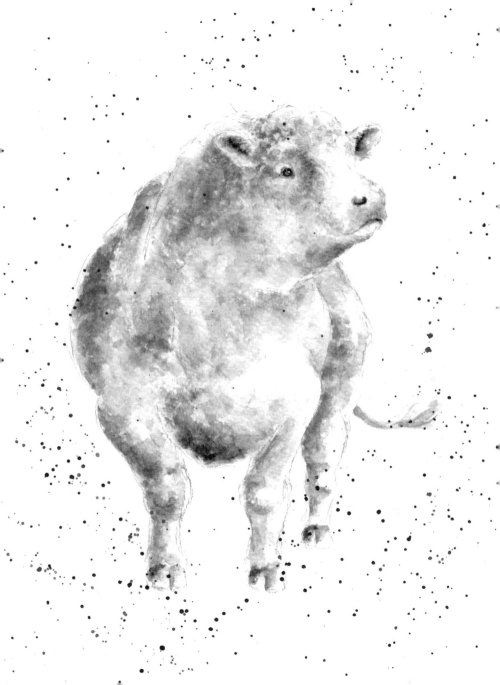

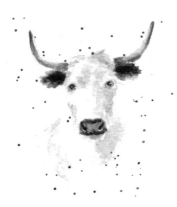

White Park

The White Park, with its snowy coat and black eyes, nose and ears is a real beauty, and with its gentle personality, was once a common sight across Britain's grazing pastures. It is one of Britain's oldest breeds and has been kept for over 2,000 years but is now a rare breed. The White Park is descended from the wild cattle that were originally domesticated in the Middle Ages.

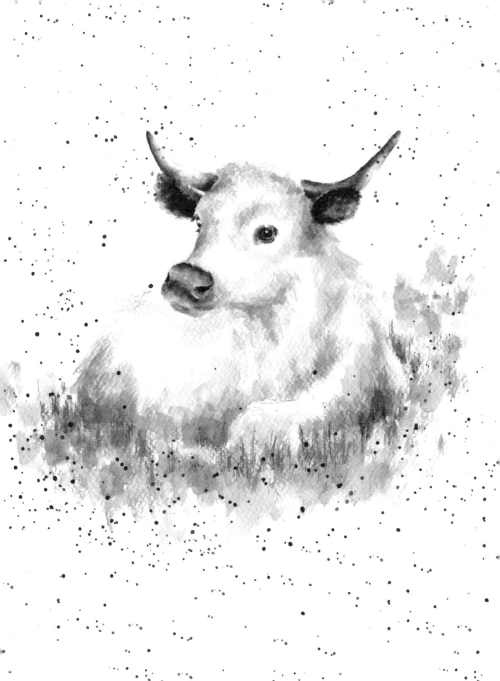

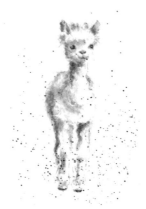

Alpaca

Not to be confused with a llama, the alpaca was domesticated 6,000 years ago by the Incas, who spotted the merits of the alpaca's luscious fleece. Waterproof, flame-resistant, strong and silky soft, it is highly prized and was once the reserve of the elite and the nobility due to its superior qualities. When it is not grazing happily on the grass with its friends, you might hear an alpaca humming. This is the primary way alpacas communicate their feelings, and they will hum at various pitches and volumes when they are happy, worried, bored, cautious, curious or distressed.

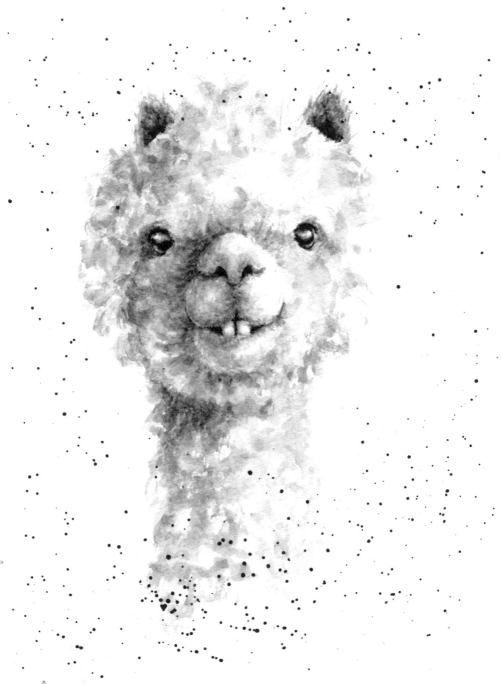

6
Flock
(Sheep)

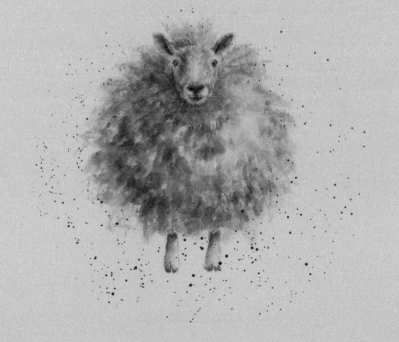

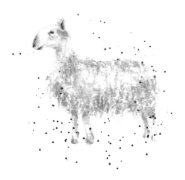

Bluefaced Leicester

The Bluefaced Leicester is a handsome sheep – tall and elegant with a regal air; its most distinctive feature is its Roman nose. It takes its name from the blue skin that is just visible through the white hair on its face. The Bluefaced Leicester is blessed with luscious, curly locks, which are prized for spinning, though its greatest value in the sheep-farming industry is as a sire. The offspring of a Bluefaced Leicester ram and the ewe of any other breed are known as Mules and are the most numerous of all commercial sheep.

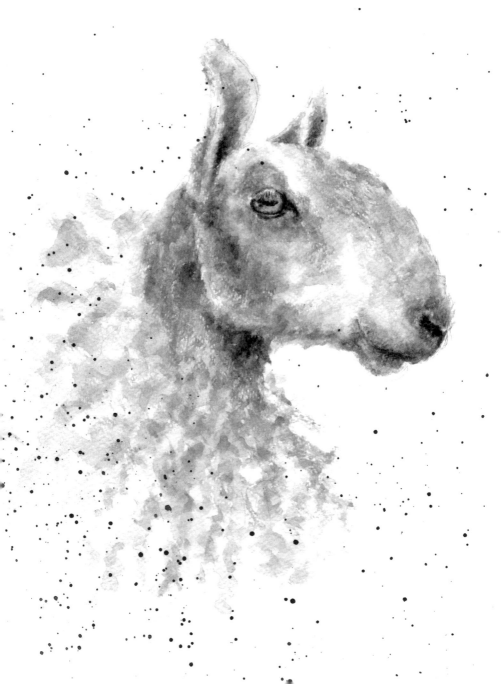

Cheviot

As the name would suggest, the Cheviot Sheep comes from the
Cheviot Hills that border England and Scotland. Hardy little souls,
they are well-suited to the windswept conditions on the hills and their
wool was once considered the finest for making tweed. The Cheviot is
an independent breed and can take care of itself pretty well – the ewes
make excellent mothers and are much less high-maintenance than
some of their ovine cousins.

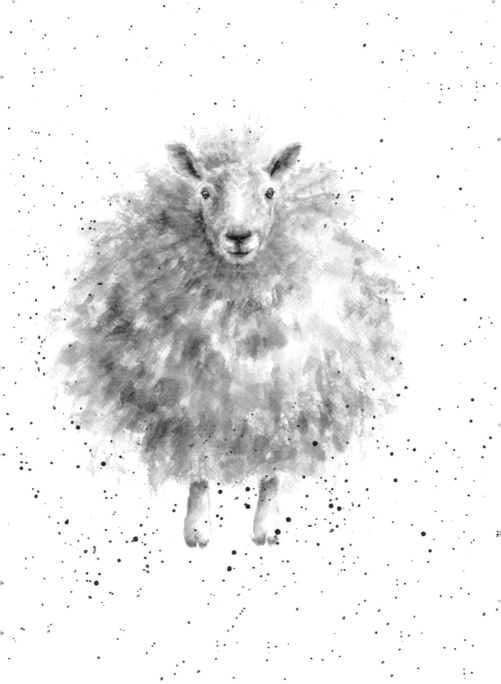

Herdwick

The Herdy, as it is affectionately known, is one of Britain's oldest sheep breeds, and its ancestors were thought to have been introduced by Norse settlers. The breed is famous for being championed by Beatrix Potter, who was even president of the breed association for a time. Found mostly in the Lake District, Herdwick's have shaped the landscape and terrain of the region for many centuries – grazing prevents trees growing on the hillsides and the much-loved dry-stone walls were built to protect and confine them.

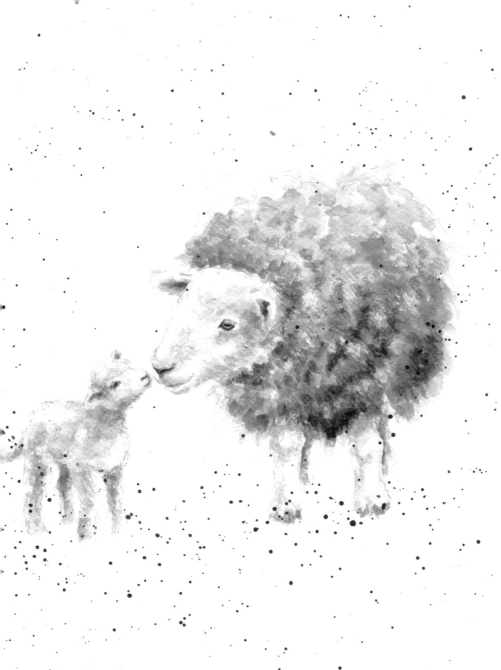

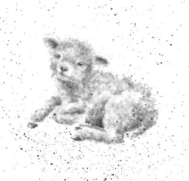

Lincoln Longwool

The Lincoln Longwool is the largest native British sheep and is, unsurprisingly, famous for its luscious locks, which cascade down its body in ringlets. The breed played an important part in our economy when the wool trade was a major contributor, but when demand for wool waned and focus turned to more commercial breeds in the 1970s, this handsome sheep almost became extinct. Rescued from the brink by some devoted breeders, our countryside is all the more beautiful for it.

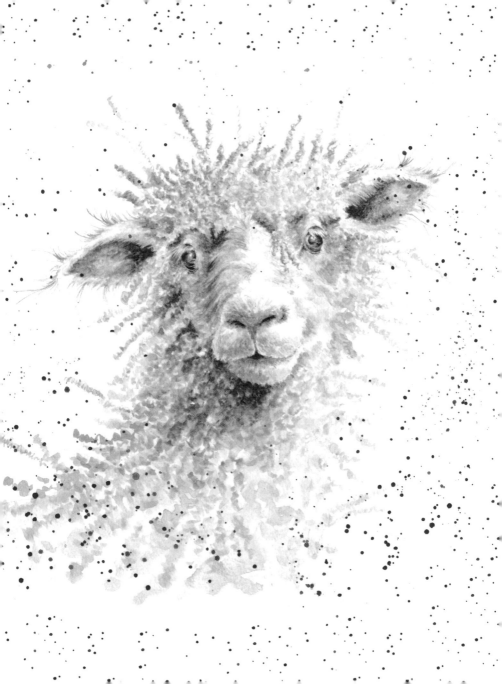

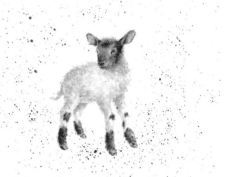

Scottish Blackface

The Scottish Blackface is the most common breed of domestic sheep in the UK and, unsurprisingly, most are found in Scotland. They are one of the hardiest sheep breeds, with their thick, dense coat protecting them against the worst of Highlands' weather. Although its origins are unknown, there are records from monasteries in the 12th century that make reference to a 'blackfaced' breed of sheep.

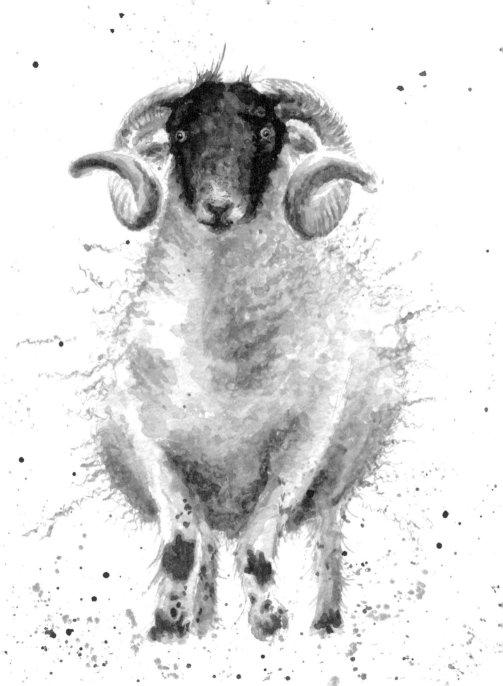

Soay

The little Soay, with its primitive appearance, is unbelievably hardy
and can survive in the most tempestuous of conditions. It takes its
name from the island of Soay, just off the coast of Scotland – in fact,
'Soay' means 'sheep island' in Norse, suggesting that they have made
the island their home since at least the time of the Vikings. The Soay
looks a lot like the wild ancestors of domestic sheep, is small and agile
and is perfectly suited to the beautiful but harsh conditions
of its island home.

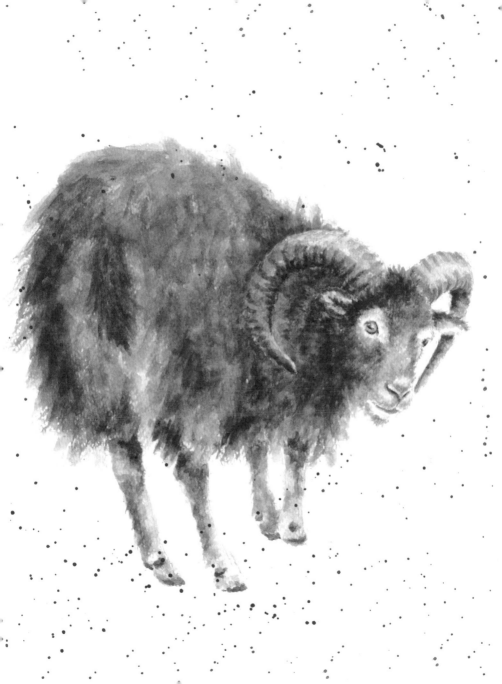

Suffolk

The handsome Suffolk Sheep was originally created by breeding
a Norfolk Horn ewe with a Southdown ram near to Bury St Edmunds
in Suffolk, hence the name. Its iconic black face makes it one of the
most recognisable of all sheep breeds, and it can now be found all
over the world.

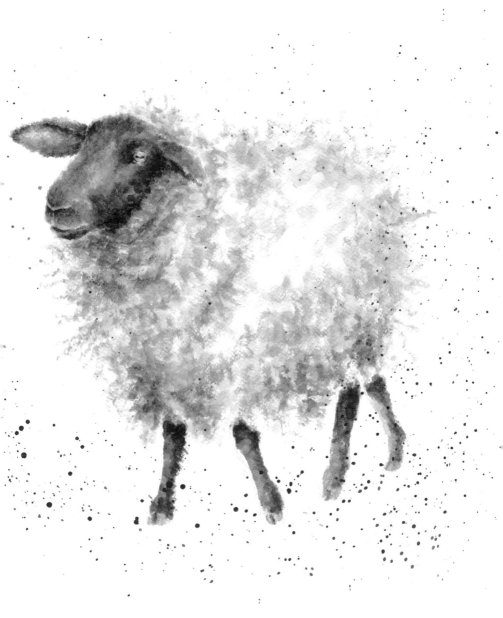

Swaledale

The beautiful Swaledale is named after Swaledale valley in Yorkshire. With its curling horns and white-framed eyes and mouth, it is a real beauty and has become iconic in the hills and dales of its home county. The Swaledale's thick coat and sturdy body make it well-suited to the most exposed environments. Swaledale sheep make excellent mothers and are able to rear their young regardless of the adverse conditions.

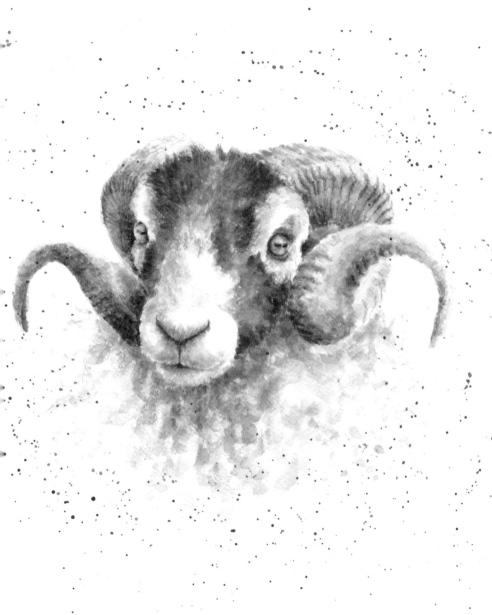

Wensleydale

The Wensleydale Sheep is most famous for its lustrous locks, which
make some of the best quality and highly valued
wool in the world. Proud and graceful, this breed originated in the
valleys of Yorkshire in the 19th century and all Wensleydales can be
traced back to an extinct local longwool breed and a Dishley Leicester
ram whose name was 'Bluecap'. Despite its glamorous appearance, the
Wensleydale is a hardy breed and thrives in the hills and dales
of Yorkshire.

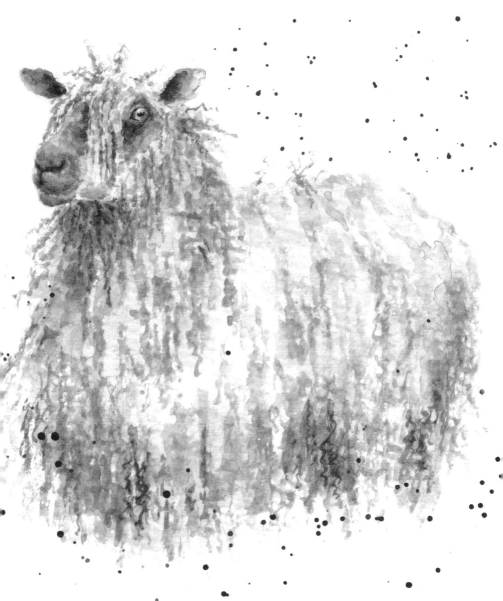

7
Tribe
(Goats)

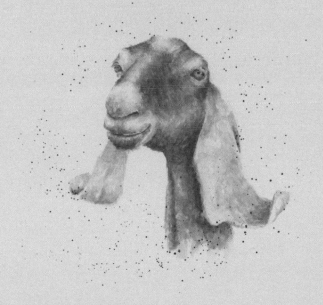

Golden Guernsey

With a golden coat that can range in colour from pale straw to fox red, the Golden Guernsey is a beautiful animal, perfectly suited to its home on sunny Guernsey in the Channel Islands. The breed almost became extinct under the German occupation of the island during the Second World War, when the invading army slaughtered livestock on the island. It owes its survival to a single lady devoted to the breed who managed to hide and rescue a few goats.

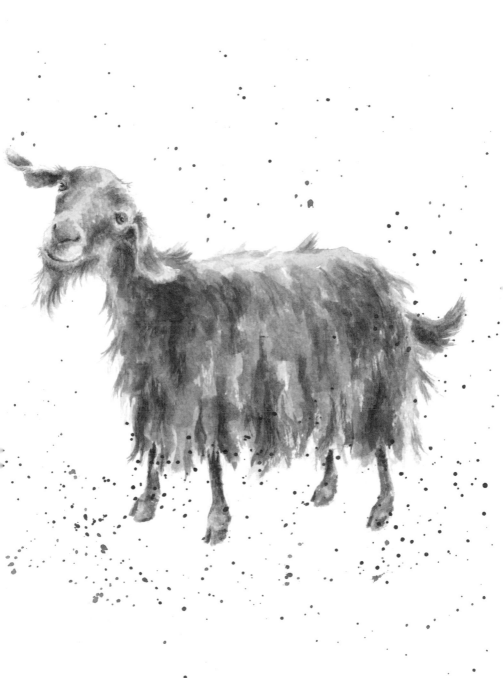

Nubian

Not to be mistaken for a character in *Star Wars*, the Nubian
(or Anglo-Nubian) is the gentle giant of the goat world. With its
aristocratic Roman nose and pendulous ears, the breed was developed
in England by breeding British goats with lop-eared goats from India,
the Middle East and Africa. Sociable, intelligent and vocal, the
Nubian is now found all over the world.

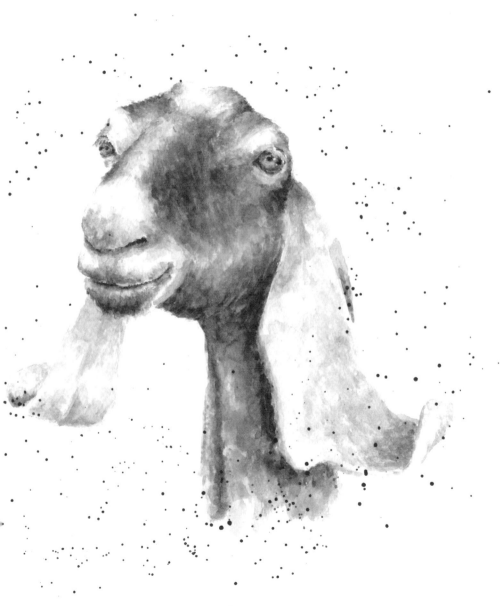

Saanen

The snowy white Saanen is Switzerland's best-known goat, originating in the valley of the same name. It is now the most widely distributed dairy goat in the world thanks to its prolific milk production, hardiness and sweet nature.

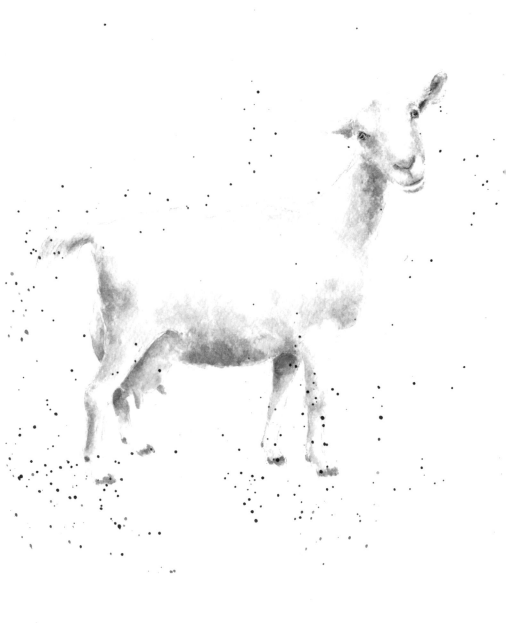

Alpine

The graceful Alpine Goat is well adapted to navigate the steep mountain ridges and rocky slopes of its ancestral home in the French Alps. Friendly and curious, goats were one of the first animals domesticated by humans, amongst them the Alpine. It is now best known for its rich milk, which is made into butter, cheese, soap and ice cream amongst other things.

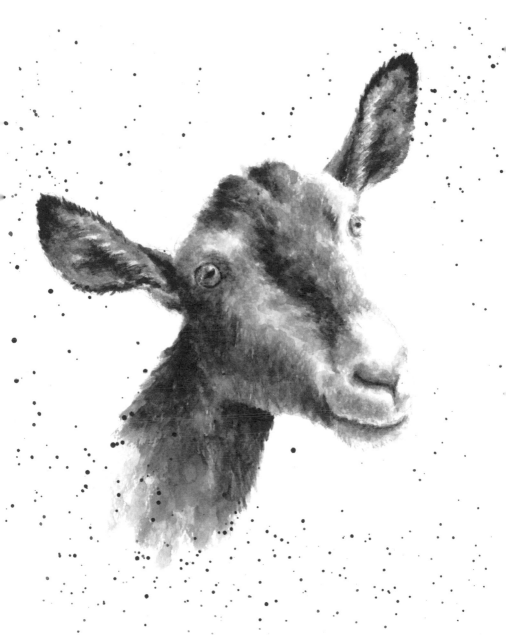

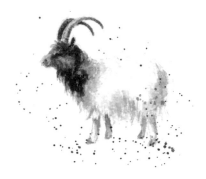

Bagot

The Bagot Goat has a long and distinguished history in Britain. It is thought to have been brought back by Crusaders in the 14th century and a herd was given to Sir John Bagot by King Richard II. For hundreds of years, the goats have lived happily at Blithfield Hall in Staffordshire, the home of the Bagot family, even featuring on their coat of arms. As befitting its noble heritage, the Bagot is a haughty character, mainly trading on its good looks.

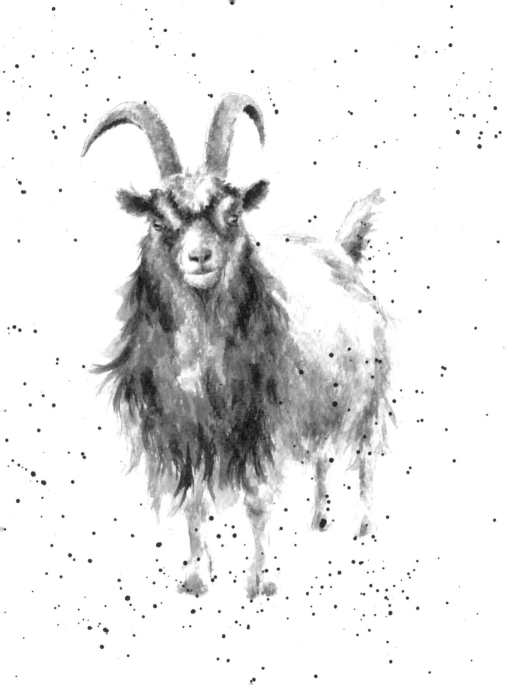

Index